SIGNS OF HOPE

SIGNS OF HOPE

MESSAGES FROM SUBWAY THERAPY

MATTHEW "LEVEE" CHAVEZ

BLOOMSBURY
NEW YORK · LONDON · OXFORD · NEW DELHI · SYDNEY

Bloomsbury USA
An imprint of Bloomsbury Publishing Plc

1385 Broadway	50 Bedford Square
New York	London
NY 10018	WC1B 3DP
USA	UK

www.bloomsbury.com

BLOOMSBURY and the Diana logo are trademarks of Bloomsbury Publishing Plc

First published 2017

ISBN: HB: 978-1-63557-080-9
ePub: 978-1-63557-081-6

LIBRARY OF CONGRESS CATALOGING-IN-PUBLICATION DATA IS AVAILABLE.

2 4 6 8 10 9 7 5 3 1

Designed and typeset by Katya Mezhibovskaya
Printed and bound in China by C&C Offset Printing

To find out more about our authors and books visit www.bloomsbury.com. Here you will find extracts,
author interviews, details of forthcoming events, and the option to sign up for our newsletters.

Bloomsbury books may be purchased for business or promotional use. For information on bulk purchases
please contact Macmillan Corporate and Premium Sales Department at specialmarkets@macmillan.com.

This book is dedicated to
all the people who wrote
something, volunteered,
smiled, laughed, cried, or
in any way participated in
Subway Therapy.

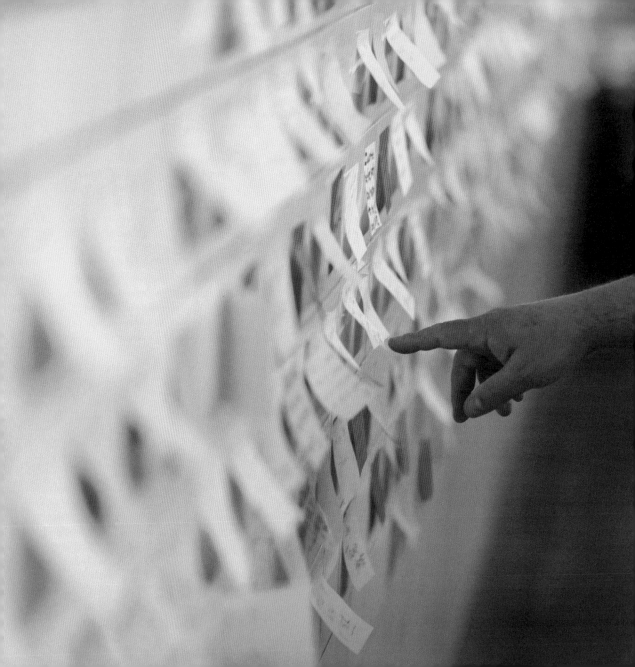

CONTENTS

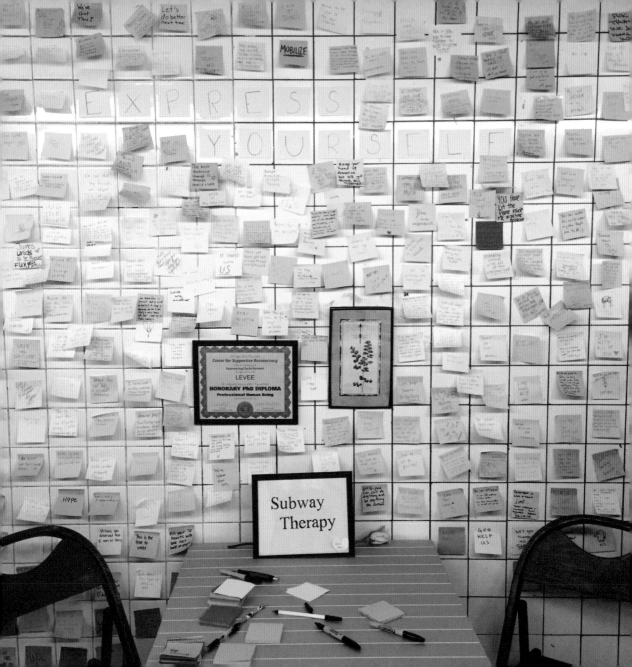

INTRODUCTION:
A TABLE AND
TWO CHAIRS

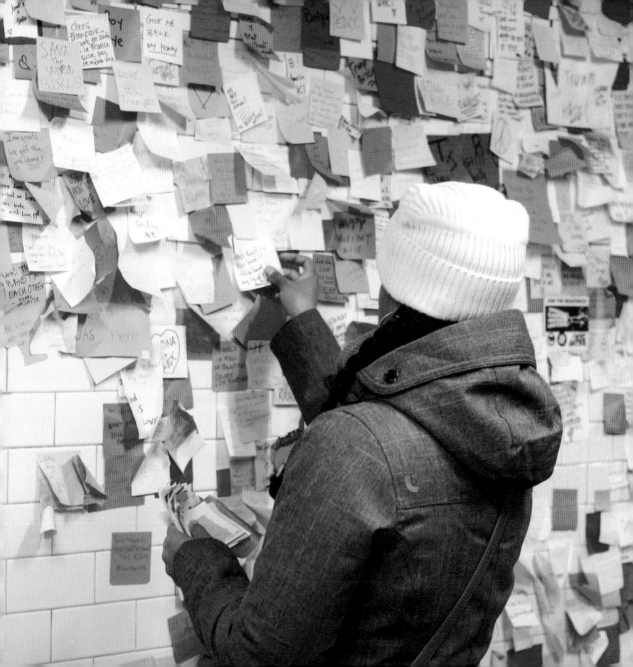

Levee [lev-ee]: an embankment along a river
that prevents flooding during inclement weather.

NEW YORK IS ONE OF THE MOST DENSELY POPULATED CITIES in the world, and yet it can often seem like the loneliest, especially on the subway, where New Yorkers stand and sit shoulder to shoulder every morning and afternoon without so much as making eye contact. The city is too fast-paced, the screens on our devices too absorbing, the press of bodies too disturbing. But in my first weeks in the city, as the news reminded us hourly that we were a country divided, I detected something else: a special restlessness in the air, a desire to break through the commuter glaze and communicate. I wondered, as an artist, listener, and teacher, could I help New Yorkers engage with those around them in a meaningful way?

I positioned myself at the 3rd Ave subway platform on the L train, along with a table, two chairs, a blank book yet to be written in, and a cardboard sign that read "Secret Keeper." It took about five minutes for a curious passerby to stop and inquire what I was doing. I presented the book and encouraged him to write down any truth that was weighing on him. "The emotional burden of your secret won't be as heavy for me," I said. "I'll help you carry it."

Within a few short weeks hundreds of New Yorkers had shared with me their innermost concerns. I didn't take payment, though many kind souls offered; I wanted to show them, and myself, that some good things could be free. The practice taught me to love listening: While many did

This city gives me hope. We'll make it through.

3

choose to write down their secrets, the majority of those who stopped by my table really just wanted to talk. I often heard some version of, "This is great! It's like therapy!" (I assured everyone that I am not a licensed therapist.) The name kept coming up, so I decided to make it stick. On May 22, 2016, I added a "Subway Therapy" sign to the wall behind my setup.

For the next six months, on a weekly basis, I would set up my Subway Therapy office—a card table and chairs—listening to the people of New York. One day I talked to a woman, a recent immigrant, for three hours about her yearning for a community she could trust. She'd been hurt, taken advantage of since her arrival, and though she had a specialized foreign degree, she saw a future here of menial work far below her potential. There was the daring photographer who showed me images taken from inside subway tunnels. (From now on, whenever a train conductor has to slow down because of someone walking the tracks, I'll think of those images, their sheer beauty, and the way they bring the underground to light.) Another day, a charming and articulate eighteen-year-old told me about how he wanted to develop medications to slow aging, then asked, "Can I talk to you about being black?" And he did.

Though I had started it for the sake of others, the project was changing my own experience too. Riding the train back to Brooklyn each night, I began to consider the fullness of those around me and across from me, the outstanding complexities that made up each life. How thin the barrier could be between those lives and myself—just a matter of invitation. I loved that Subway Therapy allowed me to ask, "Would you like to sit down?" And I loved that most did—even those drawn to the

4

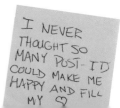

"office" with laughter, snapping pictures—people from every race, religion, sexual identity, age, socioeconomic profile, and many other designations. The one commonality was that each participant was desperate to be heard by someone.

The day before the 2016 presidential election, many people stopped by my table to speak about their apprehension, how scared and uncertain they felt. The following morning was a dreary one for a majority of New Yorkers: a morning of surprise, anger, disbelief, and, for some, elation. A palpable tension coursed through the air. I wanted to extend the reach of Subway Therapy, to multiply the opportunity for spontaneous expression. I stopped by a store on the way to the train to buy extra supplies, remembering how my mother, a grade-school teacher, used sticky notes in her classrooms to get her students to open up.

At 2 p.m. I set up my table, chairs, and signs in the bypass tunnel that connects the 6th Avenue L train and the 14th St. 1-2-3-F-M trains, a long, quiet walkway where I knew that I would not be in the way of busy commuters. One letter at a time, I wrote "EXPRESS YOURSELF" on pieces of white paper and taped them up on the wall above my table. Then I picked up a pad of sticky notes and wrote "I'm sad my friends are upset." I peeled the note off the pad and affixed it to one of the cold white subway tiles above me, leaving the remainder of the pad on the table for others to use. Almost immediately, someone stopped to write. Soon there was a flood of people scribbling around me, some lingering to read the notes left by others. Some would stop to speak; others wrote, read, even wept.

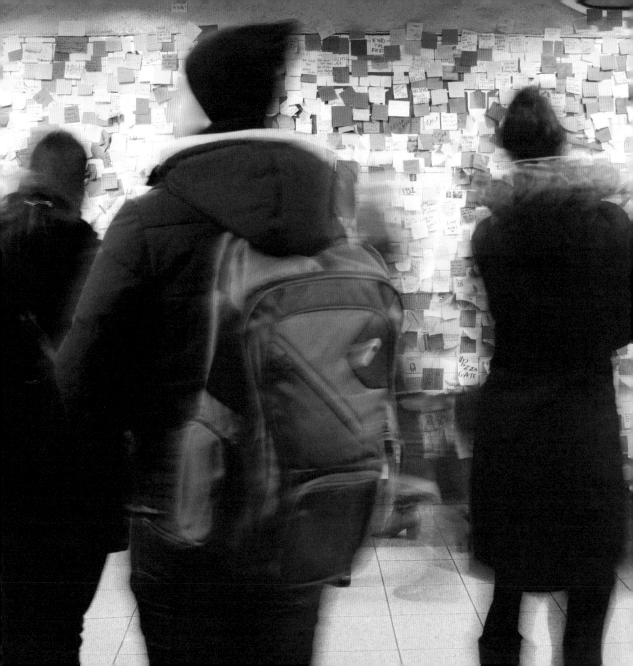

Something was happening. I couldn't leave, so I called my best friend, Adam, who showed up with a bagful of sticky notes in all colors. Soon news crews arrived to capture footage of the scrum. By midnight there were two thousand handwritten notes on the wall, a mosaic of human emotion.

At the end of the day I wasn't sure what to do. Would the notes be removed and disposed of if I left them behind? Would they be vandalized, swept away? I felt responsible for them, but also to the people who had left them behind. In my exhaustion, I could think of only one option: I would take the notes down that night and bring them home with me, then put them back up again the next day. Carefully peeling each note from the wall by myself that night made for a strange sort of meditation. At 2 a.m., as I sat alone in the empty tunnel, all traces of the day stowed safely in my backpack, sticky notes were spontaneously spreading like rainbow-colored ivy in other subway stations across the city. New Yorkers were connecting with one another.

Within days, walls of sticky notes popped up in San Francisco, Seattle, Boston, Washington, D.C., Oakland, and other cities around the nation and abroad. Teachers sent me pictures of walls their students had created, others would tell me about sticky note walls in offices, stores, and even on the mirrors of public restrooms. Each morning that followed, a group of friends and passersby helped me put up thousands of notes in the tunnel, and each night new people stopped on their way home to help me collect the originals and the thousands of new notes that had been written that day. I'm eternally grateful for the help of these volunteers of far-ranging political leanings.

This feels better than Facebook...

The sticky note project has been called a visual representation of the voices of the people of New York: some confused, some scared, some angry, but so, so many that are loving and hopeful and inspiring and proud. I have seen the notes turn countless strangers writing alongside one another into neighbors, children into their parents' teachers, and sweethearts into fiancés (several people used the sticky note wall to propose marriage to their beloveds). New Yorkers from all across the political spectrum contributed. And though the wall became a phenomenon around a political event, its power is not limited to political discourse; the wall has presented a larger opportunity for people who would not ordinarily interact or understand one another to connect, feel empathy, and find common ground.

I hope these notes speak to you as they have spoken to me.

A note on my name: I grew up next to a levee in Gilroy, California, and my friends and I would go there often. I loved watching the trickling creek of the dry season transform into a powerful force with the rains. And I loved the steady neutrality of the levee—just there, not stopping the surge but directing it, managing the overflow, many times saving our neighborhood, our homes. One of my goals has been to help people channel strong emotions, and I chose the name Levee as a way to embody this.

BETTER DAYS ARE AHEAD.

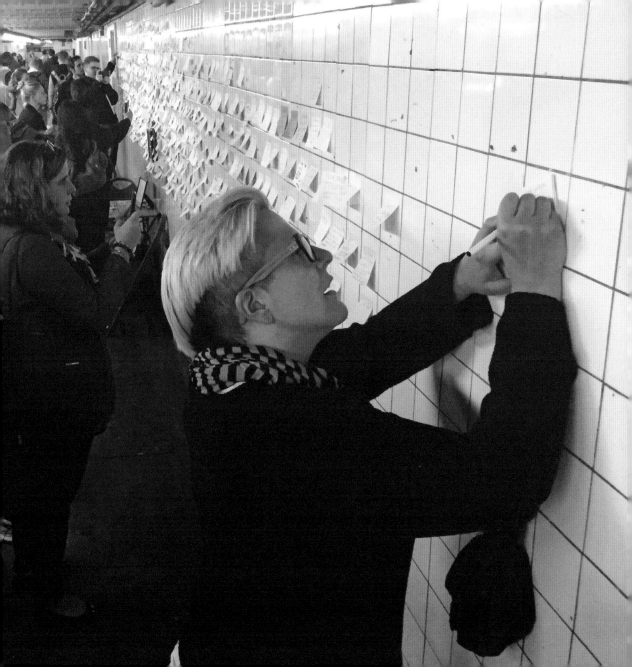

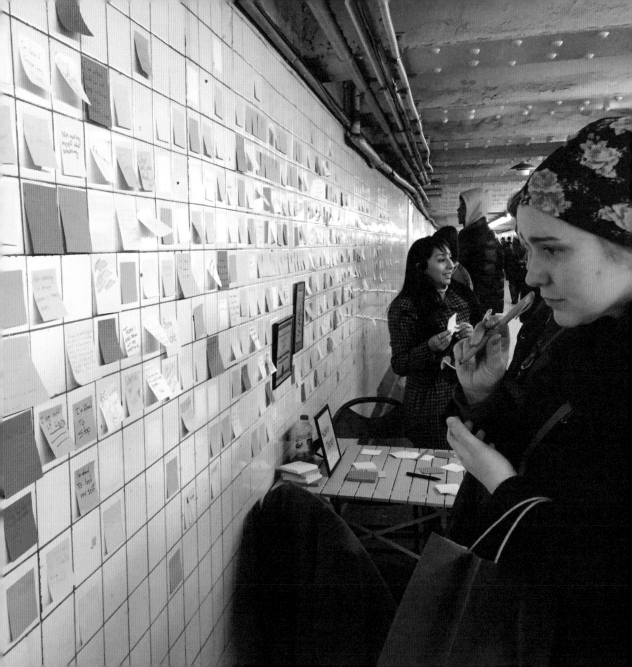

MY HEART IS HEAVY

My heart is heavy.

I felt so hopeless, until I saw this.

i'm not at all sure its going to be okay

I wanted to move + run away. But I need to stay and stand up for what is right. Speak up and make things better. The kids are listening.

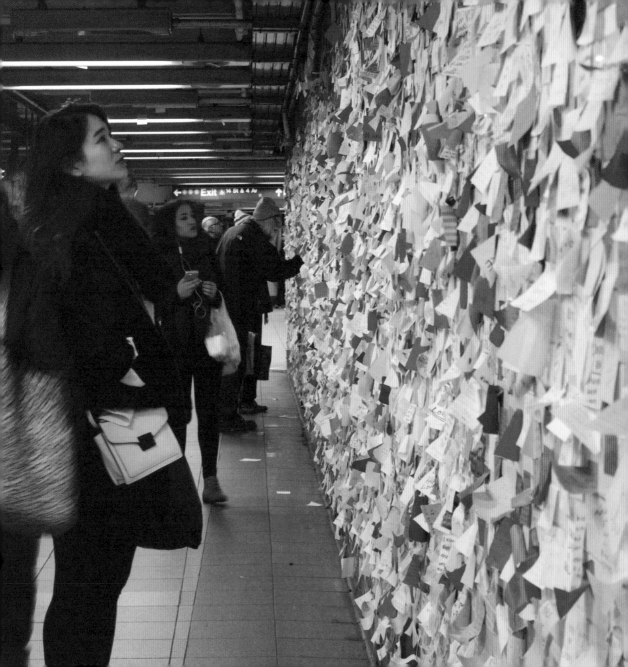

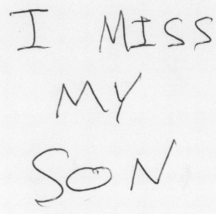

I MISS MY SON

WOKE UP IN the Twlight Zone .

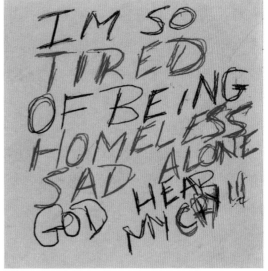

IM SO TIRED OF BEING HOMELESS SAD ALONE GOD HEAR MY CRY !!!

I JUST WANT TO FEEL OKAY.

I feel alone and
extremely anxious
I just wish I
had friends

Disappointed.

I miss when
wanting things
was never
accompanied
by shame.
or guilt.

I attempted
suicide.

Freezer doors aren't
effective.

But I'm still here.

We will get
through this

I am filled with
fear and confusion.
I am uncertain
of my future.
And I feel unsafe.
in my home.

Why
Just Why

May God help me
with Physics & Calculus.

Amen

I REALLY
MISS
YOU ROSE

I WANT TO
KNOW WHY
I'M ALIVE

I WISH SOMEONE WOULD BE THERE FOR ME

Why do I Feel most alone when I am surrounded by people?

SAD

I AM A TRANS GUY AMERICAN WHO FEELS LIKE HALF THE COUNTRY LOOKED PAST THE VALUES WE ONCE WERE SO PROUD OF PLEASE REACH OUT AND TELL PEOPLE LIKE ME THOSE VALUES STILL EXIST. FEELING LOST

In times of difficulty, Make Good Art -Neil Gaiman

I dont even Know if im gone make it to the next day every day I wake up an I fell life its my DeathDay!!!

Sometimes the light bulb burns out and I don't have the energy to change it... BUT I'M TRYING

I was raped 3 years ago. 1 person knows.

I'm 15 and honestly I think my generation is doomed and noone even cares

I feel
invisible.
I feel alone,
Now at least
we can feel
that way together

I feel lost
then I see
A smile on
a stranger and
everythings ok!

This wall helped
me through a time
of feeling alone.
Thank you.

Don't forget to
breath

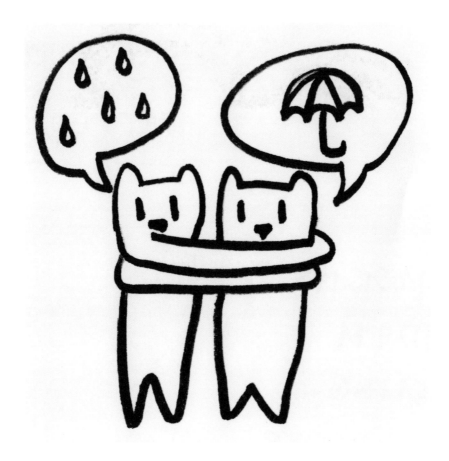

I hit a man in a bar last night. He harassed me and the woman I love & tried to kiss me. I'm so sad.

...it is
HURT PEOPLE
~~that~~...
HURT PEOPLE

5 POST ITS
AND I'M
FEELING
MUCH BETTER

I want to move on and heal but I don't know where to begin

"There's still some good in this world, Mr. Frodo.

AND IT'S WORTH FIGHTING FOR."

– Samwise Gamgee "The Brave"

I HATE

MY JOB BUT HAVE

NO OTHER

OPTIONS

i so, so hope that we can learn to be a little more gentle to each other. that we can show more compassion. that we can cultivate LOVE and JOY and a deeper awareness of our interconnectivity. smile more. move slower. breathe.

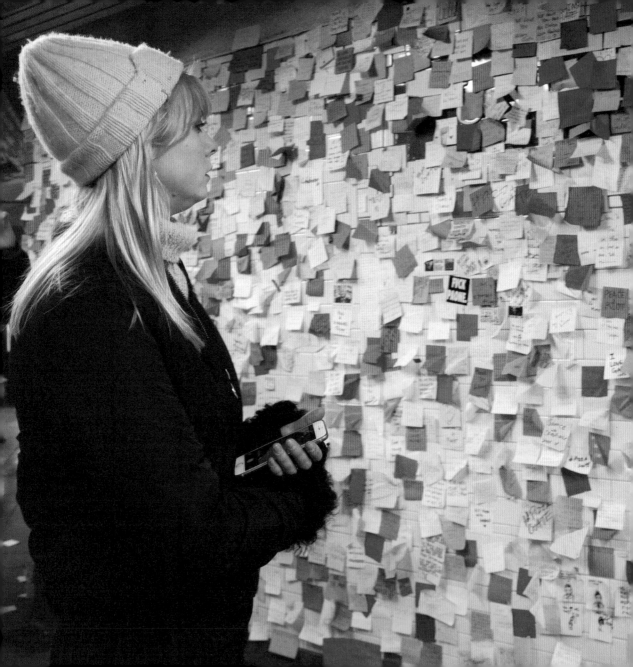

IT IS HARD
NOT TO FEAR
THE FUTURE

I'm ~~terrified~~

I don't want to be afraid for 4 years

I'm afraid of Not being in control. I'm afraid of not being able to fix things

I'M SO SCARED FOR NOT ONLY THIS COUNTRY, BUT THE ENTIRE PLANET

I'm sad and scared, but glad I'm not alone

I'm afraid that if people know I have a mental illness — they'll misunderstand and judge me. I want to tell people and break the stigma #MENTALMOVEMENT

Never becoming the actress I want to be ♡

Amounting to nothing That all my work was pointless

- Never Living To my Potential
- Not being loved
- SPIDERS ← No, really
- People w/ NO LOVE IN THEIR HEART.

I don't
want to
be lonely

It is hard
not to
fear the
future.

I want to be
proud to be a
woman. But I just
feel scared.

That I
will not
be able to do
all the things
I want to in
life

my partner
never
being
happy .

"There is
nothing to fear
but fear itself"
-FDR
1932

I am afraid
of crazy,
violent
people .

I'm afraid
of fear

AS a first-gen muslim-american, a woman, and a rape survivor, I am scared. But this country was always built on the backs of women of color, and we always survive with dignity and grace.

I am afraid. I am also hopeful. I think.

heart broken & terrified. I feel rootless. My country isn't what I thought it was. It isn't what I thought it stood for. I am devastated.

I WANT TO BE A GOOD PARENT TO MY 12 YR OLD + Teach HIM TO BE KIND

DON'T BE SCARED,
YOU ARE NOT ALONE,
I LOVE YOU,
NEW YORK LOVES YOU,
AND WE WILL
PROTECT YOU.

To everyone
afraid right now,
we will help to
protect you.

I am a Muslim. In private I am afraid, frightened whats to come in my community.

In Public, I will AlWAYs Be unapogitically <u>Muslim</u>

—Muslim.

If you are afraid, I will walk with you.
I will stand beside you in the face of hate and deflect it to protect you.
I Love You

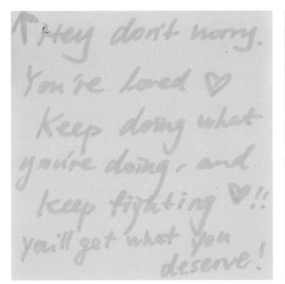

Hey don't worry.
You're loved ♡
Keep doing what you're doing. and keep fighting ♡!!
you'll get what you deserve!

Remember we all just want to be safe and happy. Let us provide that for each other, NO MATTER WHAT.

Love each other and STAY fEARLESS. ♡

NOT Having A Family ♡

Snake

My students missing their window of opportunity 100

Time

The loss of my memory and bits of who I am

The unknown

WHAT ARE YOU AFRAID OF?

People misunderstanding me

I want to make a difference in somebody's life.
Afraid of being alone and leaving someone alone

RAPE

the future

Being alone

Death

failure

phone calls when i only want text...

I wont ever see my brother.

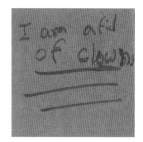
I am afd of clowns

Leaving this world without making a change

Not being able to raise my children→adults

Being alone in a room Full of People

I'm afraid of going outside at night when I'm camping

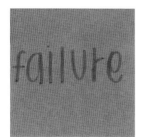
Not My life does not matter. I will disappear. I cannot make a difference. When I die no one will remember me

not living up to my fathers expectutions

- Spiders
- The Dark
- Being Alone

NOT BEING SUCCESSFUL, & DISAPPOINTING MYSELF

Marrying the wrong Person

I'm Afraid To Stop

I might be bipolar

I AM AFRAID OF NOT REALIZING MY TRUE POTENTIAL. AKA I AM AFRAID OF MYSELF

I am afraid of
fear being the
main motivation
for my actions.

I am
afraid
of spiders
because
they have
fangs.

I am afraid of
I cannot go to college even
I work hard and try my
best. I am afraid of I will
be deported to my country, I
am afraid of nobody on my
side, I don't want to be
alone.

I'm
afraid of
myself, when
I'm angry.

I'm afraid I'll always be afraid of something.
I'm afraid of change but afraid I'll never change

I'm Afraid of losing the people I love

I'm AFRAID OF HEIGHTS AND EVERY ANIMAL IN AUSTRALIA

I'M Afraid of being Alone.

That my Boss is right.

NOT FINDING "TRUE LOVE" ← ♡ → EVER!

OF NOT Being Missed When I'm gone ∵

I'm afraid of not reaching my FULL potential, my destiny.

I'm afraid of Fascism coming to U.S.A.

getting old.

I'm afraid all my dreams will never come true

I'm afraid I'll disappoint every one who has believed in me. And whales

I'm afraid of not falling in love

I AM AFRAID
I WONT GET
MY EX WIFE Back
AND I'M AFRAID
I WILL

FRIGHTENED
YET
HOPEFUL ♥
〰〰〰〰〰

INSECURE...
-no idea
what to
E X P E C T...

I must not fear. Fear is
the mind-killer. Fear is the little
death that brings total obliteration.
I will face my fear. I will
allow it to pass over me and
through me. And when it has
gone past I will turn my inner eye
to see the path. Where it has gone
there will be nothing. Only I will remain.

We're all scared.
Have courage,
walk towards the
fear, and through
it, find love.

I'm scared of how tired I already feel.

I am GAY And

I am Terrified

I'm afraid of losing my Mom

we are going to have to be the strongest smartest, most focused versions of ourselves to survive this. Grieve today, take care of yare self & then others. Get off the internet - I'll meet you in the streets.

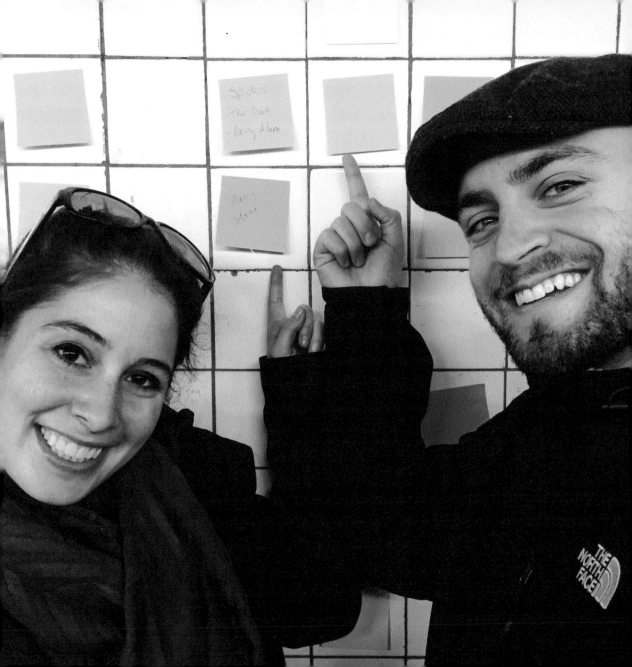

DEAR STRANGER,
I ♥ YOU

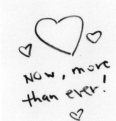

NOW, more than ever!

LOVE ALWAYS WINS

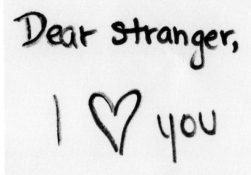

Dear Stranger, I ♡ you

AMOR y PAZ ♡

It hurts to love you.

I love my Girlfriend

I ♡ my boyfriend but he likes dudes

LOVE YOU, BUG

LOVE YOU GUYS

We love + Miss "u" Antoine xoxoxo

I love you, Ben! ♡

I LOVE ALL YOU PEOPLE

I LOVE you Amin ♡

BE HONEST IN
EVERYTHING
YOU SAY.

LOVE HARD.
THE MOST IMPORTANT
THING IN THE WORLD
IS HUMAN CONNECTION.

LOVE 愛.

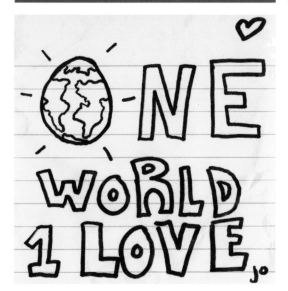

ONE WORLD 1 LOVE.

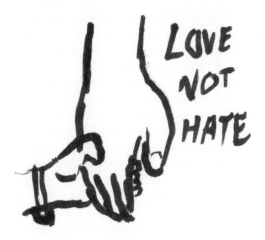

LOVE NOT HATE

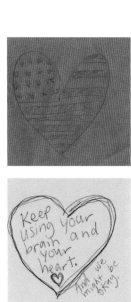

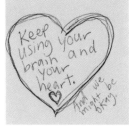

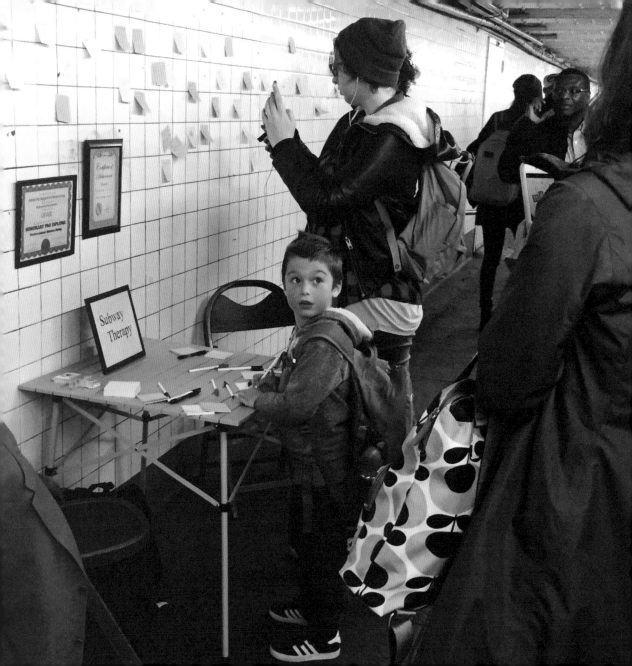

♥ lets
Be there
for one another.
lets love. lets
listen. We all matter.
♡ M xo

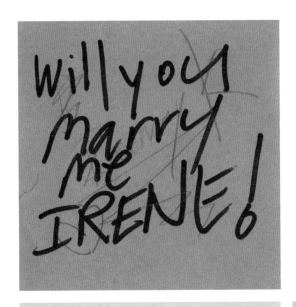

LOVE

There is only
one happiness
in this life, to
love and be
loved. ♡

MCL
WILL U
MARRY
ME?
11/28/16 · AZB

53

LOVE is ♡ THE MOST IMPORTANT

(from Spain)

LUH YO SELF!! ☺

I want more Love in my Life

This has made me realize that I have friends that care and who I love.

real Love from my mommy and everyone who is in my family

I want a boyfriend

I want her not to grow up too quickly!

Yo fall in love with the most handsome, kindest, funniest man ♡

I wonder if the Woman of my Dreams is on this Train or maybe The next one maybe that's her ♡

I WANT EVERYONE TO REMEMBER TO TREAT EACH OTHER WITH RESPECT

I Love You
If No one
said it to you
today I LOVE
You!

사랑

♡

Hello Humanity,

How beautiful
you are when
you're filled
with love ♥

SPREAD
LOVE,
IT'S THE
AMERICAN
WAY

I ♥ that I'm free from him!

Love is Love is Love is Love is Love is Love is Love is Love is Love is Love is Love is Love

MAS AMOR ♡

"Love me without restriction,

Trust me without fear,

Want me without demand,

Accept me for who I am."
 — Unknown —

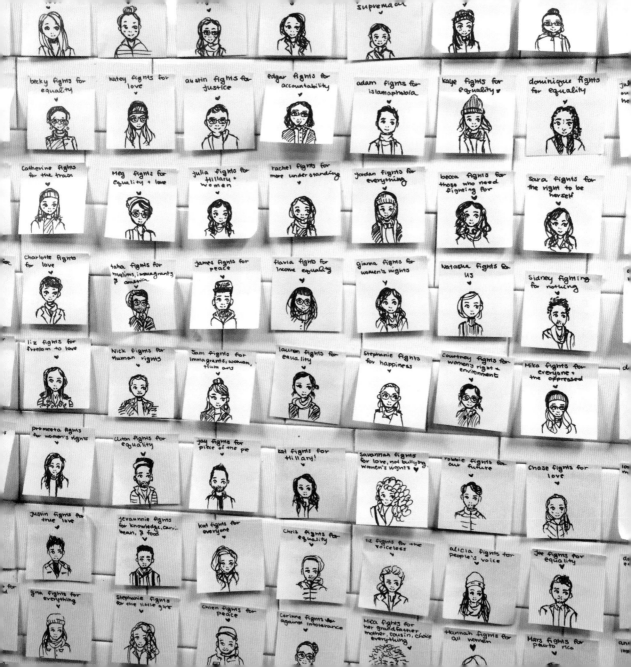

TAIWAN
🏴 No.1

ve here
be here

♥

TOGETHER
OUR LOVE &
PO

LW E

NO JUSTICE STRONG
 FEELINGS...
NO Thank you
PEACE For helping
 me feel this
 again

NEVER
STOP
CARING

THANK YO
TO:
FROM:
☐ MUCH APPRECIATED ☐ SO HELPFUL
☐ FOREVER INDEBTED ☐ MADE MY DAY
☐ SHOULDN'T HAVE ☐ MY HERO
REGARDING:
Bye, Bye USA ☐ VERY MUCH

FREE
PRESS
MATTERS

STRONGER

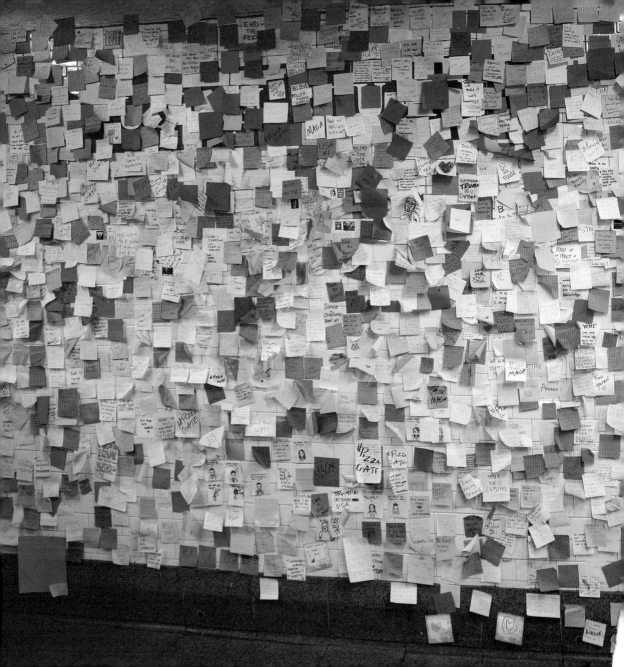

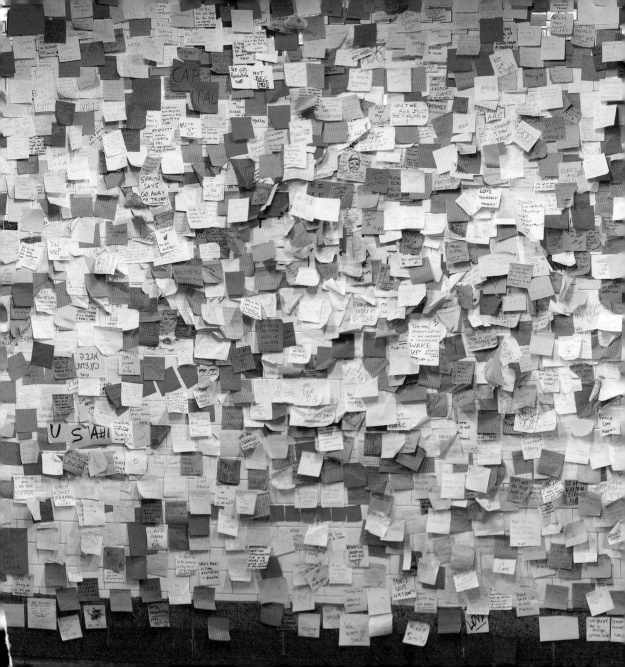

USE THIS
PAIN + ♡
GO HIGHER
DO BETTER

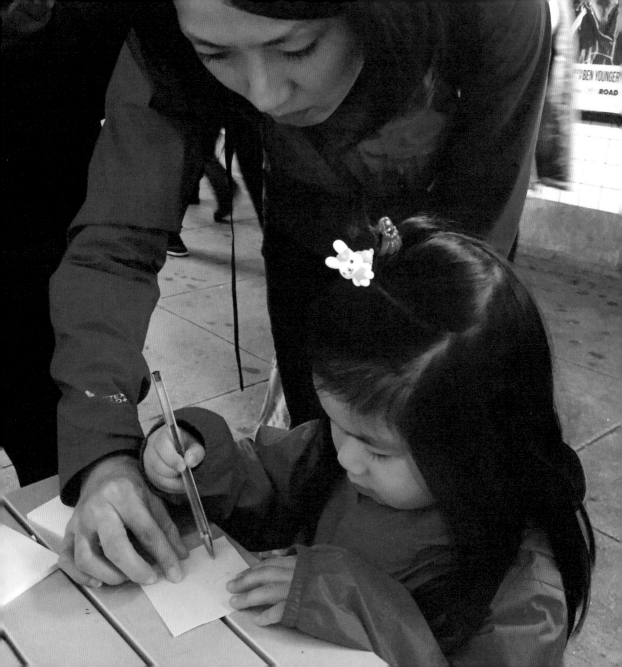

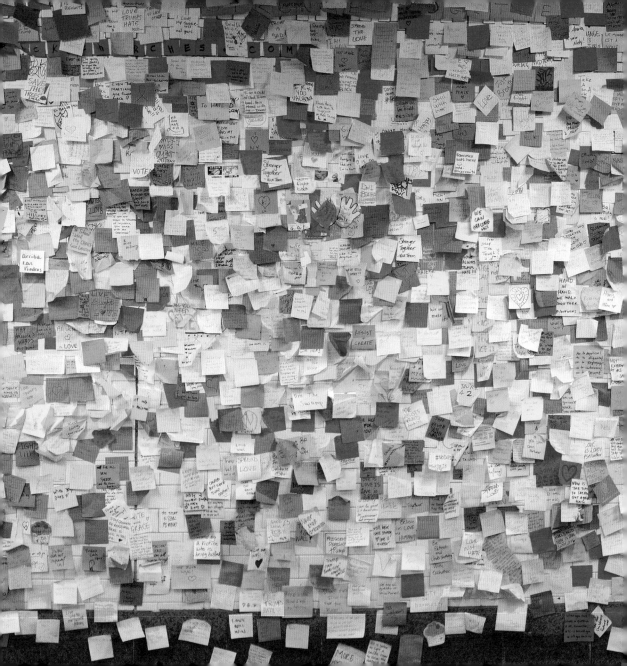

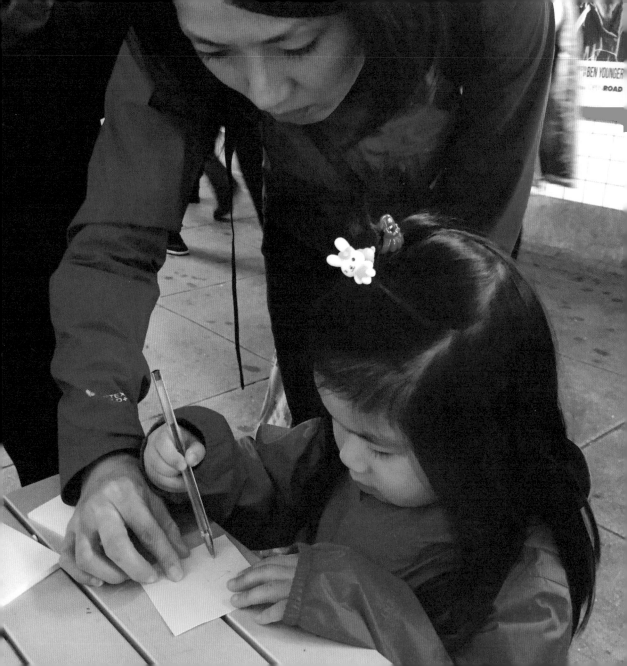

USE THIS
PAIN + ♡
GO HIGHER
DO BETTER

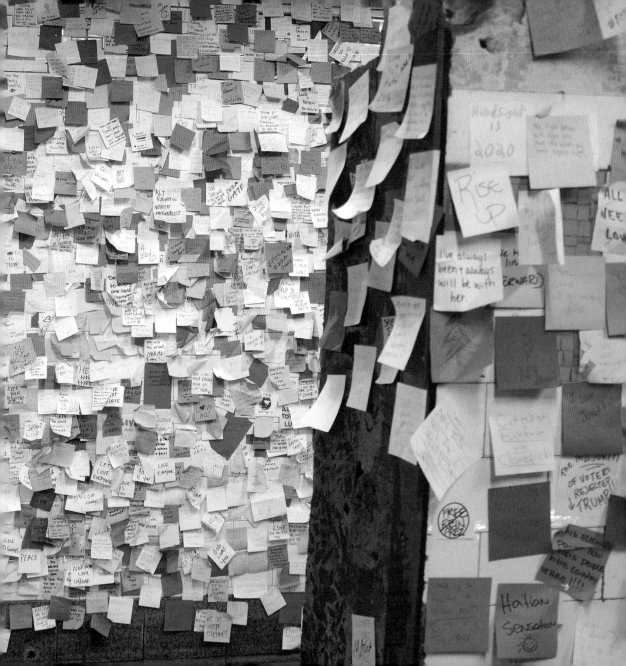

FIND YOUR HOPE AND HOLD IT CLOSE

everything will be

OK

Hug the ones you loved a little tighter. Never stop smiling. We are Strong and we are loved. We will get through this together!

Look around, look how lucky we are to be alive right now. History is happenning. →

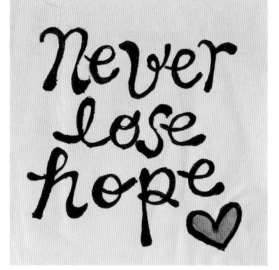

never lose hope

THIS IS
THE
BEGINNING!

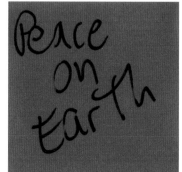

Peace
on
Earth

So glad I live in a
city where something
like THIS exists.

#hopeishard

Find your hope

and hold it

close

Bend,
Don't
Break

XXX

戦争なき世界を
共に目指そう？

I can do it!

You can do it!

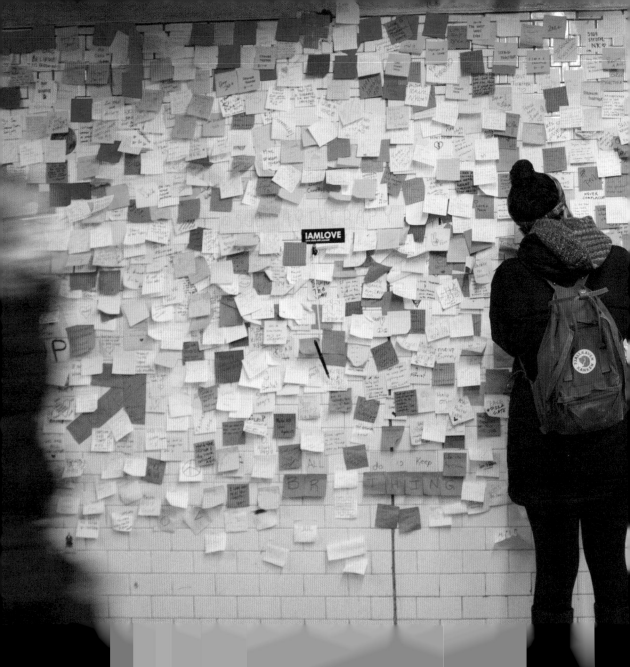

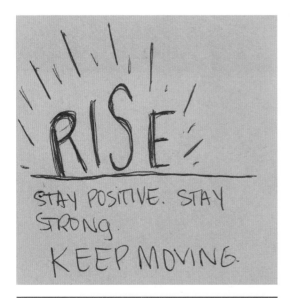

RISE

STAY POSITIVE. STAY
STRONG.
KEEP MOVING.

NYC

PEACE AND
INTELLIGENCE
PREVAILS

HOPE
&
PEACE

Practice radical
empathy
Practice radical
empathy
Practice radical
empathy ♡

Here's to
tomorrow.
Whether we're
invited
or not.

11-11-16

No matter
what I'm
still making
my dreams
come
true.

We all came from
the same place and
will end up in the
same place.
We are all one.

Rise ⌃up...

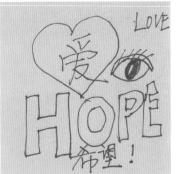
LOVE
HOPE
希望！

I have to Believe that Together we'll all Be OK

I believe we all are human beings with love in our hearts and potential. That potential should not be crushed by negative views of our world. We are in it together LOVE, PEACE, JOY, HAPPINESS TO ALL ♡☺

UNITY IN HOPE
WE MUST STAY. UNITED. ALL HUMANS SUFFER AND STRIVE FOR HAPPINESS EVERDAY.
♡

Human history consists of a series of peaks and valleys. Right now we are just in a dip...

I BELIEVE IN You, AMERICA! YOU CAN DO ANYTHING YOU PUT YOUR MIND TO

We've got this. We can do anything.

I will die a prisoner of hope.

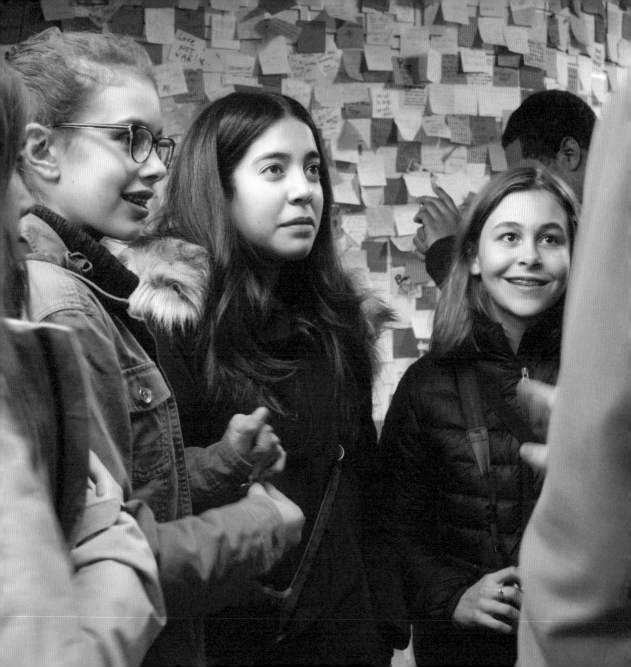

YOU Have Lit the flame inside ME. #ONlY the BeqiNNiNq

A Dream is A Wish Your HEArT MAkes

you are stopping to read this. your heart is hopeful. So is mine.

Dream big.

Keep open minds and open hearts. Have faith. You're not alone.

Above the clouds the sun is always shining. Love will always win. ♡

YOU'RE SMART KIND IMPORTANT

These notes give me hope.

Always choose LOVE. ♡ Never lose HOPE.

"The world
only spins
forward "

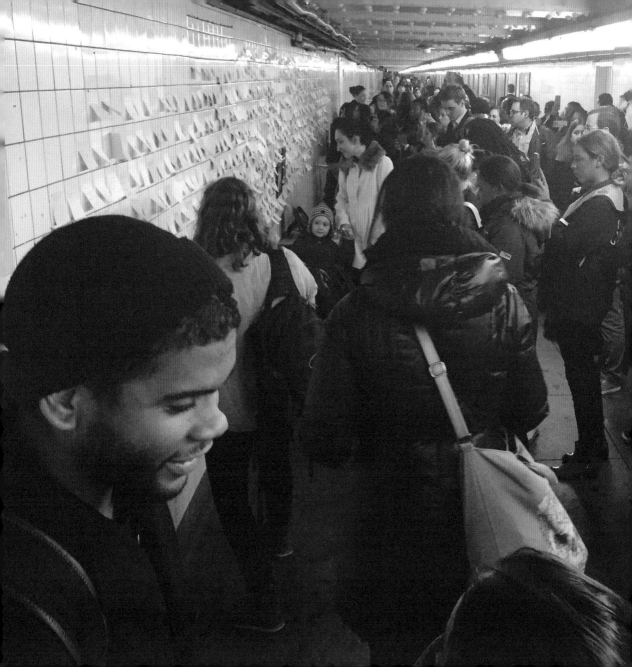

I WANT A WORLD WHERE MY GRANDCHILDREN WILL BE SAFE!

STAY POSITIVE

Stay hopeful, friends. We have so much strength together.

Pugs & Hugs

"Happiness can be found in the darkest of times, if only one remembers to turn on the light."
- Albus Dumbledore

Thank you, New York for speaking up. The world is a better place because of you. You are our hope!

IF you're reading this, you inspire me.

Connecting to our shared humanity is our only way forward ♡

"For the wretched of the earth, there is a flame that never dies Even the darkest night will end and the sun will rise" Don't forget, press on ♥

YOU ARE NOT ALONE
WE ARE NOT ALONE
=
AND WE CANNOT LET
THEM FOOL US INTO
THINKING WE ARE.

IT TAKES RAIN
TO RECOGNIZE
SUNSHINE.
NOTHING LASTS FOREVER
INCLUDING THE PAIN!

"WINTER CAN'T HOLD BACK THE SPRING, NO MATTER HOW DARK IT MAY SEEM."

As my eyes flutter open to
the light that has come
I give thanks to Hashem for
another chance to see the sun
In the night that covered me
In the dark dreams that plagued
my sleep
I awake know my body may be
broken but my unconquerable
spirit I keep
It matters not how straight the gate
I am a letter in the scroll
I am the master of my fate
I am the captain of my soul

My strength Prayer

IT MIGHT GET
WORSE,
BUT IT WILL
GET BETTER

I hope I get this NYPD JoB

I don't have hope, but I have determination.

My kids give me hope ♡

Thanks New York for making me BELIEVE again.

HOPE IS A THING WITH FEATHERS, GIVE IT A PLACE TO LAND

THIS ♡ ♡ WORLD IS FOR ♡ ♡YOU!!!!

Let's DRINK! Let's enjoy! Enjoy your Life Baby

THE IMPORTANCE OF KINDNESS IS MORE PRONOUNCED THAN EVER NOW. Love EACH OTHER - IT'S THE ONLY WAY OUT OF THE DARK ♡

On 11.28.2015 I tried to KILL MYSELF. It's almost 1 year later and I thank God everyday it didn't work. KEEP FIGHTING

The youth will make up for the mess you all made

The Sun Still rises

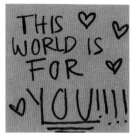

My faith in humanity will never fade. i love you ♡

just keep swimming

Build for future generations

You are BEAUTIFUL no matter what THEY say !! ♡ ♡

Positive not Negative!

THINGS CAN

chaange

There's a sense of togetherness wafting over the city, a sense of solidarity in our pain. I believe that pain will turn to fight. I want to still have hope.

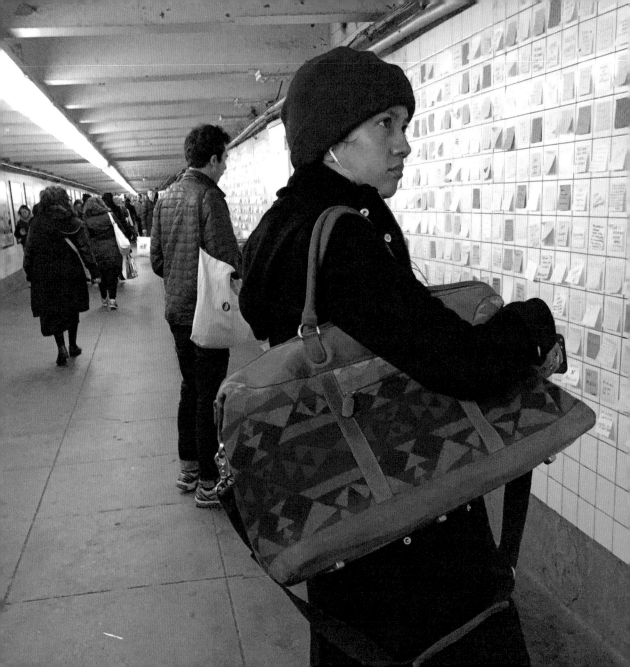

LISTEN TO
EACH OTHER

TO MY FELLOW
JOKE MAKERS,
SATIRISTS,
COMEDIANS
AND TROUBLE
MAKERS.
IT'S TIME
TO GO TO
WORK.

"eat good food, get
some sleep, hug your
friends. democracy
is messy and you
need strength."
—My Mom

Artists Unite

DONT
TAKE
THINGS
PERSONAL

Keep your head
up,

You dont want to
drop your
crown.

We'll find new
ways to express,
new ways to
create.
Yes we will.

Nice
→

I will teach
my children
to love, share,
be kind, learn,
not judge.

LISTEN
TO
EACH
OTHER

Travel
A
Lot!

I DARE YOU TO SIMPLY LISTEN.

(TO EACH OTHER)

MAKE TONS OF ART!!

Be kind, for people are fighting a battle you know nothing about ♡ ♡

Diamonds form under intense pressure and temperature. Something

WHEN YOU LEARN TO LIVE FOR OTHERS, THEY WILL LIVE FOR YOU

We've got problems

Let's Taco 'bout 'em!

Get FUNKY ☺

WHEN THEY GO **LOW**, WE GO high.

Back to Basics Remember the GOLDEN RULE

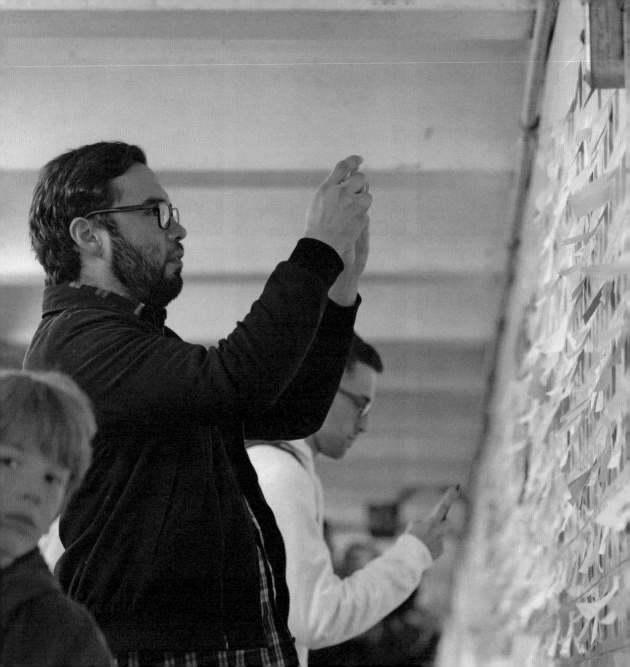

VENT

CREATE

LET GO

We just need to be are self and be the best we can xo

It's only easy to hate if we don't know each other's stories

Tolerance is not the same as inclusion — if you love all, then include all, even those you disagree with

Doubt is a
sign of your
intelligence

ALWAYS QUESTION

"We can be changed by what happens to us but we won't be reduced by it"
– Maya Angelou

Drink Your Ovaltine

WOMEN CAN DO IT

Live through the music that speaks to you !!!

life is a RISK

Happiness can be found in the darkest of times, if one only remembers to turn on the light ♡
BE the Light.
BE LOVE..
TEACH Kindness
TAKE CARE OF EACH OTHER

Artists Unite!

Let this inspire the next generation of Real leaders, Starting with YOU!

BELIEVE IN HUGE-MANATEE

Education
is
Liberation

For the "other people's children" I teach and ♡ everyday!!

Teach love
Teach love
Teach love
Teach love
Teach love
Teach love

STORIES ARE IMPORTANT NOT BECAUSE THEY TELL US DRAGONS ARE REAL

BUT BECAUSE THEY TELL US THAT THEY CAN BE ~~XXXXXXXX~~ DEFEATED

Also, mistakes happen

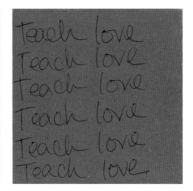

educate others.

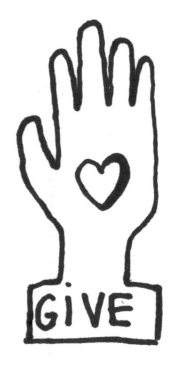

GIVE

Trying my best to teach empathy and kindness everyday to children and adults. It's hard!

There is nothing that blooms for the entire year. Don't expect yourself to do the same

CULTIVATE
LIGHT

SPREAD IT
INTO THIS
DARKNESS

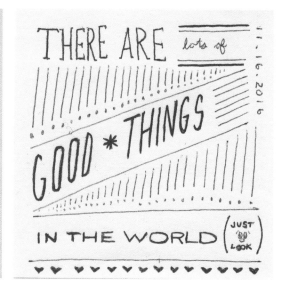

THERE ARE lots of

GOOD * THINGS

IN THE WORLD (JUST LOOK)

11 . 16 . 2016

HATE is
not healthy
for children,
and other
living
things...

Give more than
you take every
day

There is a
crack in everything,
that's how the
light gets in.
♡

FOLLOW
YOUR
HEART

"ART is
our weapon!!
Paul Robeson
— we need you
now

Educate our
young ones.
Protect our
young ones.
Empower our
young ones to
create change.
- Future Teacher ♡

Life is
an adventure
so search
for your
treasure of
Life

HAVE
CONVERSATIONS
NOT
ARGUMENTS

You are not alone,
this wall is proof of that.

And remember that
you have your relatives
and then you have your chosen
family, surround yourself with
the people who love you.

Money doesn't
taste good on
ANYTHING.

I AM
WOMAN

hear me
ROAR!

Protect
your
friends
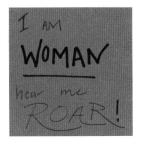

IF YOU CAN'T
BE HAPPY,
BE FEARLESS

Be kind!
Be accepting!
Love eachother
♥ ♥ ♥

This post-it is
whatever you
want it to be.
Just like your perception
of Love

keep thinking
keep reading
keep asking
questions
LISTEN.

I want to
understand
the other 48%
b/c we are in
this together!!
♡♡♡♡ ♡ ♡

Great Relationships
only come with
Great Communication

HUG MORE.

Let's talk to understand each other + bridge the divide ♡

A dream is just a wish, without a plan. ♡

The quieter you become, the more you can hear :) ♡sigi

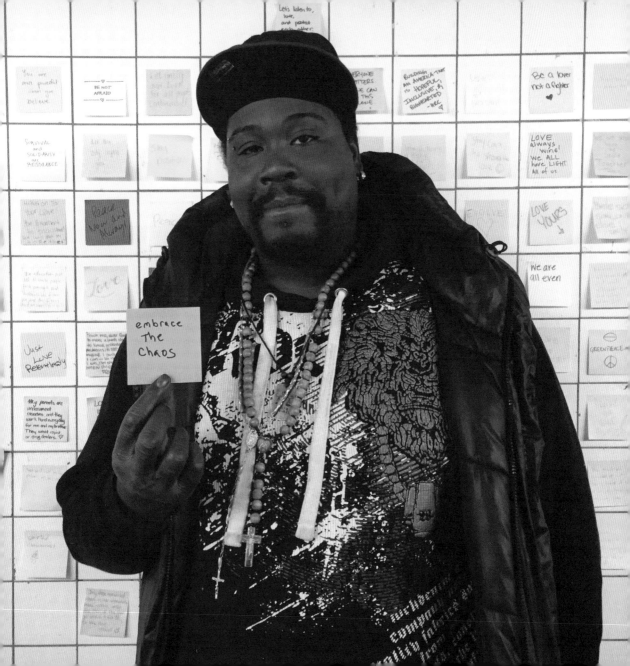

Find the
silver
linings.

Follow
your
dreams

Don't be
a victim.
Use your anger
and grief to gain
strength.

Every one
is unique
and thats
great so never
dislike your skin

you

matter.

BE THE
LOVE
THAT YOU
SEEK

Learn
Something
Dude!

NO
MORE
COMPLACENCY

MADMEN AND MYSTICS
ARE IN THE SAME
WATER...
MYSTICS CHOOSE TO
SWIM.

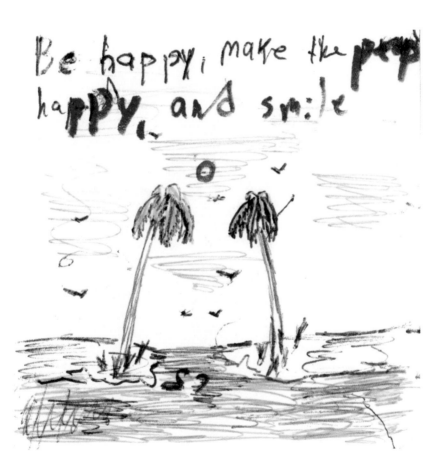

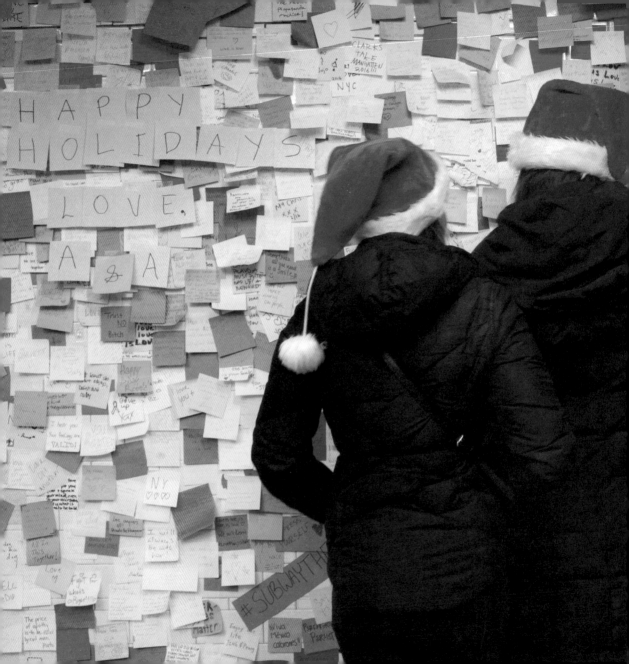

Raise your
white children
differently.
Please.

if you don't
think fate is
funny. You just
Don't get the Joke
Yet.

Communication
is key
to all
healthy
relationships

**STAY
WOKE**

HAKUNA

MATATA

Surround
yourself
with people
that help
you Grow

look
from
another
angle ♡

☝ Make ☝
ART!
It helps!
And spend time
with cats ☺

only LIGHT
can drive out
DARKNESS.....
Be the
LIGHT ☺

BREATHE IN
DEEP THROUGH
YOUR NOSE
+
OUT OF YOUR
♡ MOUTH

Don't
believe
everything
you read
♥x

There's always
time for
a cup of
coffee ☕

Get a
massage
♡
it feels good

BE
AUTHENTIC

The only thing you can
do in life is work.
God, whether or not he
exist himself, can't
and won't. Start small
and life will get
better. #SMILE

"Just because they
tell you life's not
fair, doesn't mean
you take it on the
chin and bear it.
sometimes you have
to be a little bit
naughty." - Be heard!

I Almost Felt
Hopeless ...

until I saw this
wall.

·V.R

PROTECT
YOUR
MAGIC

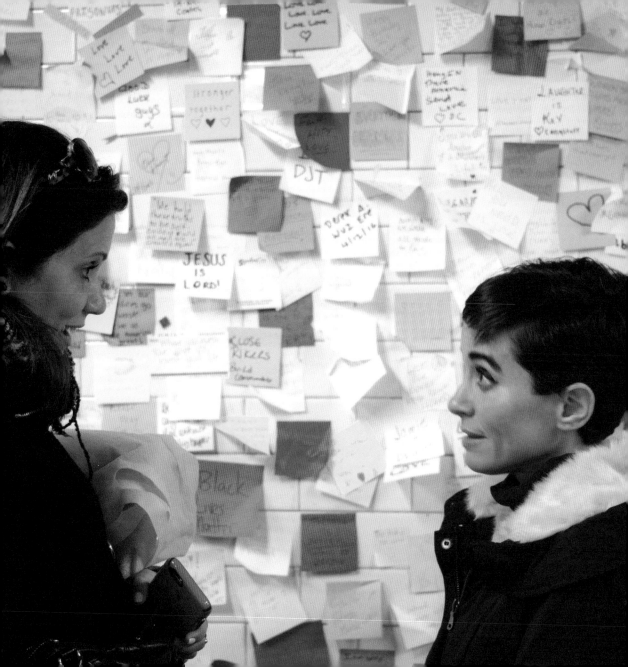

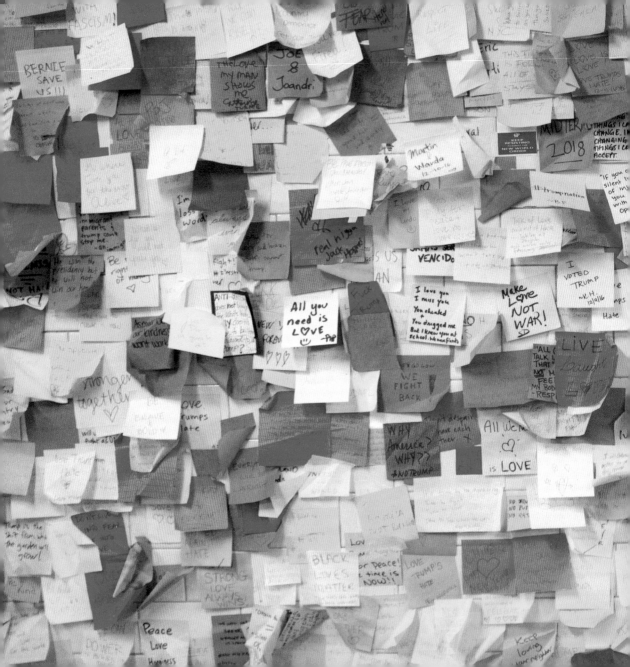

I REFUSE TO GIVE UP ON MY COUNTRY

My
heart
feels
heavy.

Everyday will pass
+ we will be stronger
for it. liberal hypocrisy
must be eradicated for
this message of
tolerance & political
unity to root.

WE ARE ALL
RESPONSIBLE
FOR CREATING
THE CONDITIONS
THAT CAUSED
THIS.

Fate whispers to
the warrior,
"You cannot withstand
the storm"
and the warrior
whispers back,
"I am the storm"

I REFUSE
TO GIVE
UP ON MY
COUNTRY

My mom
crossed the
border with
my sister on
her back,
we aren't going
anywhere

I truly believe
this is an opportunity.
If we are awake,
we can enact
change. That might
not have happened
if the election had
a different result.

To MY BLACK
AND BROWN
STUDENTS:
I AM SO SORRY
AND SO SCARED.
BUT YOU GIVE
ME HOPE.

HOW CAN I
LEARN TO
FORGIVE MY
FAMILY MEMBERS
WHO VOTED FOR HIM?

1. LET OUT A
PRIMAL SCREAM.

2. WASH YOUR FACE
WITH COLD WATER.

3. TAKE ACTION, AND
BE GOOD TO OTHERS.

I can't look forward to Christmas knowing my family voted for Trump. & I am gay.

& the hardest thing is loving them so much still, having to be the bigger person.

See you in the streets, on the barricades, in the subways —protect each other —& fight back

THE REST OF THE WORLD IS ASHAMED OF U.S.

ASK THE PERSON NEXT TO YOU IF THEY ARE OKAY.

I FEEL LIKE THE FATE OF THE REST OF MY LIFE IS IN THE HANDS OF WHITE MEN WHO HATE WOMEN. NOT JUST FOR YEARS, IF THE SUPREME COURT FLIPS.

To every person feeling fear, sadness, horror, or despair,

You are not alone. Millions of good Americans stand with you. We will stand together and we will get through this. It gets better.

As a woman of color I no longer feel safe in my own country. This is the saddest day of my life.

Yesterday I felt angry, shocked and scared. Today I am motivated to fight for my rights as a woman, for my students rights and hopefully we will collectively be able to fight back.

Decided today that I'm not having children.

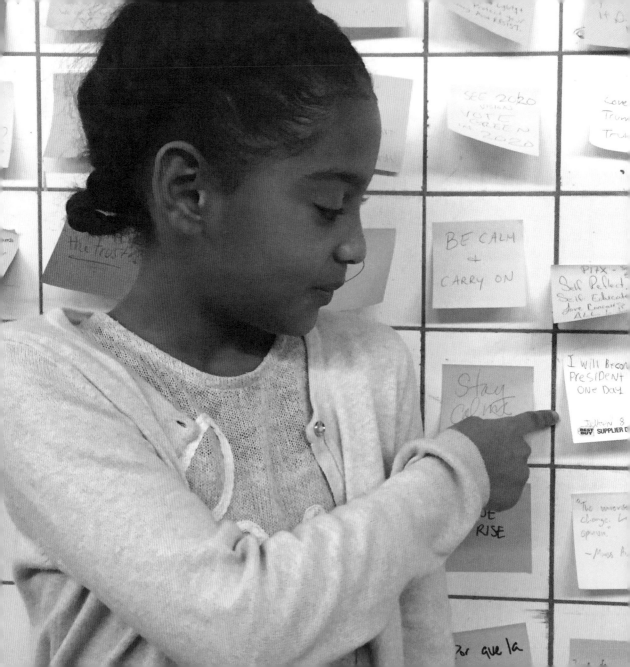

I am not an American but my son is. I will show him pictures of this wall to teach him how we can find hope in dark times, and to show him what America can and should be.

TO THE ANONYMOUS
YOUNG MAN WHO
GAVE ME A BIG
HUG & TOLD ME "WE'LL
GET THROUGH THIS TOGETHER"
AS I SOBBED ON
BROADWAY @ 55TH AT
2:30 AM 11/9, THANK
YOU. IT HELPED... A LOT

I don't
understand,
but I will try.
We need each other.

Let's channel
the passion of
this election—
on both sides—
into passion
for each other
rather than
against.

I FEEL LIKE
A STRANGER
IN MY OWN
COUNTRY

My Son Jafari,

I wish the world was a much
better place for you. Nov 9th I
cried for your future. I cried for
your generation. I pray for your
life. My generation has failed you
and other young men in your
ethnic group, & I'm sorry
Love
& Mummy

"The dawn IS coming..."

I don't need to be
here, I choose to
be here. Trump as
President is not okay
but we as a people
will be okay if we
dedicate ourselves to
change

I'm from Michigan. I now
call New York home. I
am sad, scared, broken
and tired. But Michigan
is good. New York is
good. This country is
good. Be good to yourself
and one another.

MY SADNESS IS SO
DEEP. IT FEELS LIKE
IT'S PENETRATING
INTO MY SKIN—
THE BLACK SKIN
THAT MAKES ME
SCARED OF THE
FUTURE.

KINDA
thankful for Trump...
Thankful that he opened
our eyes to the racists and
bigots out there which
in turn allowed us to
be more vigilant.
what is
to come?

TODAY, I SAW PPL HANDING OUT SHOES to THE HOMELESS

AND THEN I SAW FOLKS SINGING TO STRANGERS

SEEING THIS GIVES ME

HOPE...

BECAUSE NEW YORKERS TAKE CARE OF EACH OTHER♥

I still believe IN kindness

To those who can hear me, I say, do not despair. The misery that is now upon us is but the passing of greed, the bitterness of men who fear the way of human progress. The hate of men will pass, and dictators die and the power they took from the people will return to the people. And so long as men die, liberty will never perish.

- The Great Dictator (1940)

I AM WHITE AND
I AM ASHAMED.
I AM STRAIGHT AND
I LOVE THOSE WHO
ARE NOT.
I PROMISE TO FIGHT
FOR ALL. SPEAK UP.
I AM LISTENING.

I am a woman and
a latina and victim of
sexual assault. my
brother is gay + my
boyfriend is jewish.
I am so scared.

I have 2 children. A son
and a daughter. I teach them
about equality. About right and wrong.
They were taken from me.
I have been fighting for 3 years
to get them back. How do I
look them in their eye and
say the same things without
feeling like I'm lying now?

White, immigrant,
low-income, full time
student and I'm terrified.
I won't run away.
I will fight for the rights
I and all us New Yorkers
deserves. #I'mStillWithHer

Maybe its
time to
get to
know the
other half of
the country
♡

One man can't overpower us all.
If you are here, you belong
here. You belong in a space
where you are safe and your
family is safe and your friends
are safe.

NO ONE SHOULD MAKE
YOU FEEL YOU DON'T BELONG.
YOU DESERVE TO BE SAFE.

Why Was I
Born Black
that Was
What I Asked
My Self.
in the morning.

The day after the
election, a day after
we were filled with
such hope that we
would finally have a
female president to
represent us, my MALE
boss commented on
my appearance. I have
never felt so ashamed
to be a woman in my
whole life felt so inferior.
How would he be so

I proposed to my
girlfriend & she said yes.
We're going to get a
same-sex marriage license
while they're still legal.

Listen.

Listen.

Just

Just
Listen.

Just

Just

Just

Listen

Just

sten.

Listen.

Just

Listen.

Just

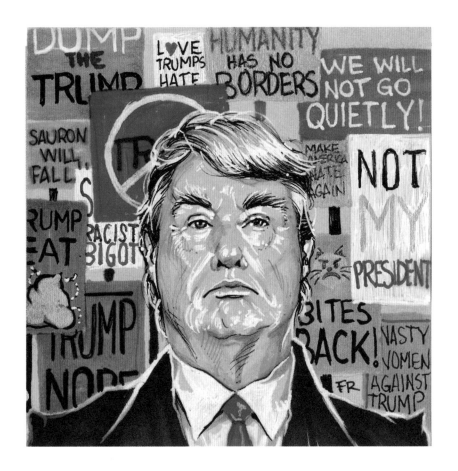

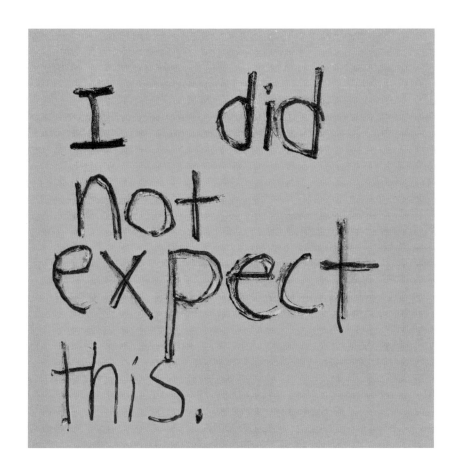

Proud to be a New Yorker ashamed to be an American

¡Somos LATINOS! ¡SOMOS AMERICANOS!

I'm White. My wife is Asian We are both Scared

I want to leave my bubble.

I'm a muslim I love America This is my home too

In the past two days I've never been more scared to be a woman.
I've also never felt more love from my friends.
It's not time to fear. It's time to FIGHT!

I REGRET MY VOTE

11/9/16
I am in Tears...
🙁

I hope he doesn't send my brother to war

FIRST BREXIT NOW TRUMP WHAT NEXT??

I'M SO CONFUSED..... AM I SUPPOSED TO START BULLYING AND INSULTING PEOPLE?
~~BABY~~ HALF THE NATION VOTED FOR THAT ☹

I don't know America as well as I thought I did.

Never attribute to malice what can be explained by ignorance

People are far more stupid than they are evil

I'm an educator. I woke up and cried. I cried on the train, I cried in front of my coworkers and students. I have never felt so awful. How many times do I have to "explain away" the evil in this world. Usually, I am the one ~~comforting my kids. Today, they comforted me.~~ Oy⊙

We won't accept hatred, misogyny, or bigotry!

SINCERELY HOPING THAT THIS IS ALL JUST A RUSE; THAT HE WILL REVEAL HIS TRUE ~~DEMOCRATIC~~ SELF-HUMAN SELF... I DUNNO, IT'S WHAT I'M CLINGING TO · AND THE HATE WILL STOP.

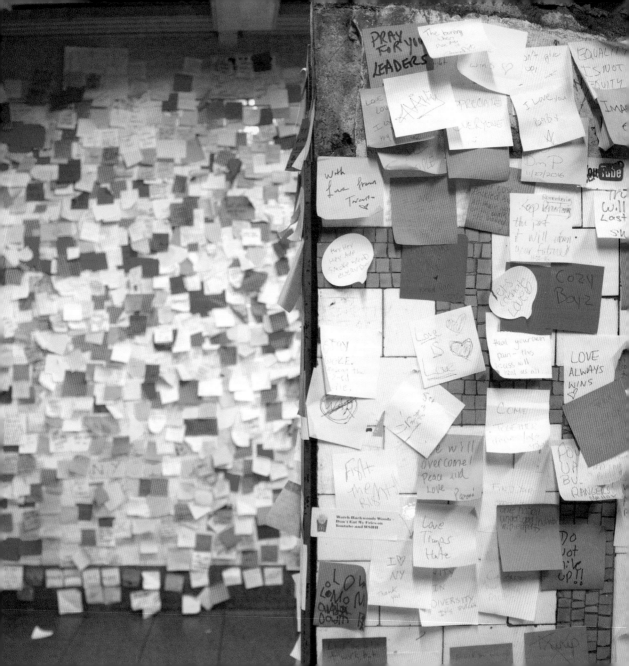

This wall shines the light
that is America.

Thank you for
making my day ♥

We may be a divided nation,
but we can fight for the
future.

"We're all got both light and dark inside us. What matters is the part we choose to act on. That's who we really are."
—J.K. Rowling

Yesterday was undoubtedly a day that changed us all. It's not certain that what we feared most will go accordingly as planned, but all we can do is hope for the best.

I will make every day mean something. I will not waste time. Trump is soon to be in office. No time to waste
—Zoe

I'm sorry I couldn't do more... that I didn't do more. I know its late but I promise this is my wakeup call. I WILL do more.

My 5 year old niece— who is Latina, female, Italian, Jewish, + the grandchild of immigrants was elected her kinder class president today in Atlanta.
#HOPE

Never doubt that a small group of thoughtful and committed citizens can change the world

It is the only thing that ever has

YOU DON'T KNOW ME
I DON'T KNOW YOU
BUT YOU'RE IN MY PRAYERS
THROUGH AND THROUGH

♥

11.10.2016

"I wish it need not have happened in my time," said Frodo.
"So do I," said Gandalf, "and so do all who live to see such times. But that is not for them to decide. All we have to decide is what to do with the time that is given us."
— J.R.R. Tolkien

Please make America Great Again.!!

123

I grieve not because of Trump, but because we live in a society accepting of racism, sexism, xenophobia, misogyny, classism, ableism – hate. What kind of legacy are we leaving behind?

I'm sorry Drew. But it will be okay.

Mom

President Obama,

Thankyou and I'm sorry.
We love you.

I cried on the train this morning and a stranger said "It'll be okay."
Im crying again. and all I el can think to myself is "I'm sorry, America"

As a teacher I question, what do we say to our students today?

I'm afraid my Nafta visa won't be valid next year. Will I have to go?

I feel like love lost.
I want to make it win again. How do we fix this?

I don't know how to protect them.
I don't know how to protect them.
I don't know how to protect them.

FEEL LIKE I HAVE BEEN PUMMELED IN THE GUT. AS A WHITE PERSON, I AM SO ASHAMED AND DISAPPOINTED. BLACKS AND MUSLIMS AND LATINXS — I STAND WITH YOU AS AN ALLY.

i NEVER
REALIZED
HOW GOOD
TRUMP
WOULD
BE

My friends across the
county are being
harassed in the street
today. I was harassed
yesterday by a Trump
supporter after voting.
I am scared for
my community.

? ? ? ? ? ? ? ?
? ? ? ? ? ? ? ?
? ? ? ? ? ? ? ?
? ? ? ? ? ? ? ?
? ? ? ? ? ? ? ?

Well in the process
of trying to bring
about "Change" you
have fallen for
the biggest con
artist we have
ever seen!!
Thanks ingnorant
America!!

I was so
shocked —
proof I have
been in the
bubble

We need this going
for 4 years.
Please.
My regular stations
are Times Sq and
Union Sq.
Please Spread

Thank You
HILLARY CLINTON
for
being an inspiration.
working to have our voices heard
& being a BOSS ASS woman
in an incredible pursuit!

DAY 3:
MY GIRLFRIEND
STILL CRIES
BEFORE BED. ‿

THIS HURTS
SO
DAMN
MUCH.
And I am sorry.

YOU WERE
FEELING ALONE
THEN YOU SAW
THIS 2,000
POST-ITs

MANCIPATE YOURSELF FROM
ENTAL SLAVERY NONE BUT
URSELVES CAN FREE OUR MINDS
HAVE NO FEAR OF ATOMIC ENERGY
CAUSE NONE OF THEM CAN STOP
THE TIME. HOW LONG SHALL THEY
KILL OUR PROPHETS WHILE WE
STAND ASIDE AND LOOK? SOME
SAY IT'S JUST A PART OF IT
WE'VE GOT TO FULFILL THE BOO
WON'T YOU HELP TO SING THES
SONGS OF FREEDOM? CAUSE
ALL I EVER HAVE
REDEMPTION SONGS
BOB MARLEY
#OURREVOLUTION

FROM WHENCE
SHALL WE EXPECT
THE A
OF D
IF
BE O
MUST O

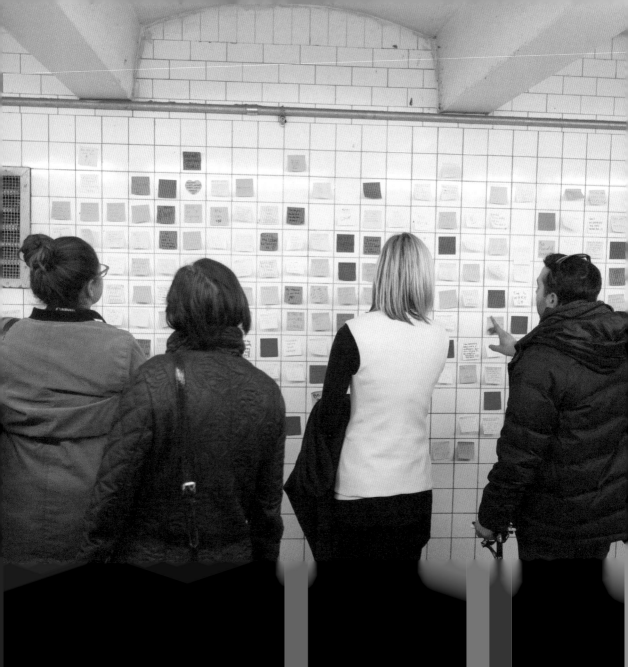

I WILL STAND UP
FOR YOU

Don't let anyone tell you, you can't do it ♥

light. We must spread Light. we won't be ignored.

Start a Movement. Keep it Moving

i will Never stop fighting for your human rights!! XOXO

Now is our time. Use your Voice!

How wonderful is it that nobody need wait a single moment before starting to change the World ♥

You are VALUABLE. You are POWERFUL. You are DESERVING.

A CANDLE LOSES NOTHING BY LIGHTING ANOTHER

Do not extinguish your beautiful light.

And I will
stand up for

YOU \longrightarrow

I WILL
STAND
UP
FOR YOU.

We are a country of
immigrants. Migration
is beautiful. My great-
grandfather was one of
the immigrants who
helped build this subway
system.

Read
Independently.
Form your
OWN opinions

Embrace this
chapter with love
and a compassionate
heart. Peace comes
from open hearts and
open discussion! ☺

"The world breaks
everyone, and
afterward, some
are strong at the
broken places."
— Ernest Hemingway

Emancipate yourself
from mental slavery,
none but ourselves
can free our minds"
— Bob Marley

A society that has
justice for only
one group is not
just. We cannot be
free until we are
all free ♥

LET US FIGHT
BACK
— 13 year old girl
in fear

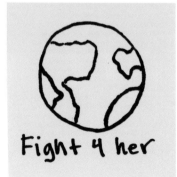

Fight 4 her

Hate breeds only
hate. Ignorance is
quelled with love
and patience. I
hope during this time
we respect all people
and be the examples
we wish we were lead by.

Sometimes I wish
I could be different,
just so I didn't
have to fear people
who hate everything
I am, for no good
reason.

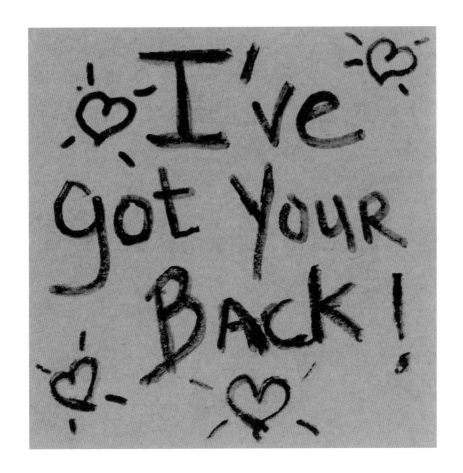

It's okay to be scared. I'm scared, too. But we can't be silent. We need to stand up for what is right — together. Stay strong, and know that I've got your back - always.

I fled my home country in search of a better life and America has given me that. Every human being deserves the same respect, grace and opportunity to seek happiness and live in peace.

We are all capable of doing great things. Life will challenge you in so many ways but through adversity come wisdom, knowlege and good Moral Character. Believe in yourself always. People will try to stop you. - Sug.o Henry

Don't let anything take away your courage. Even in defeat we are not alone. We must get up every morning and never forget the victories already won.
Take heart my friends ♡

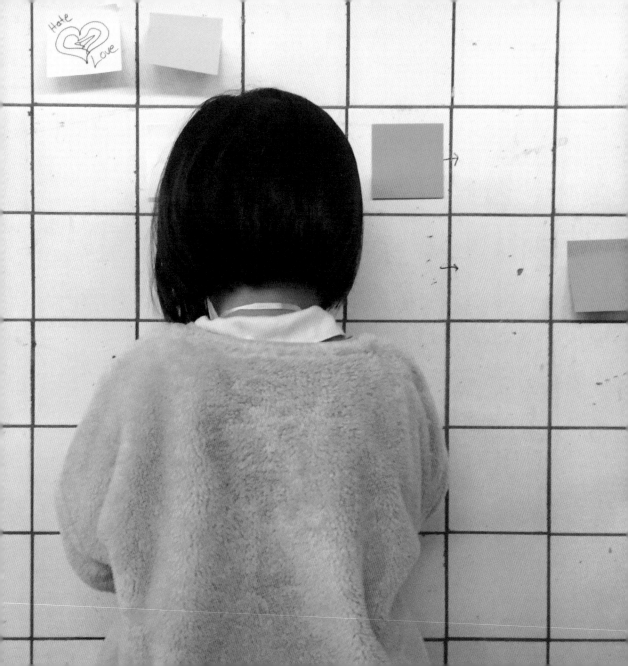

EVERYDAY I‌S A
LITTLE HARDER
BUT I KNOW I HAVE
TO KEEP GOING AND
FIGHTING FOR THOSE
THAT CAN'T.

MAY WE all LIFT
EACH OTHER
UP
AND REMAIN
RESILIENT in the
face of
"adversity"
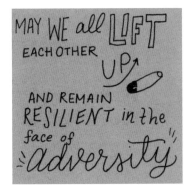

All we can do
is try to
be kind to
each other.

Small
flowers
crack
concrete
♡

PROTECT
YOUR
VULNERABLE
FRIENDS

WORK
TO
UNDERSTAND

What
candle
will
you
light?

We
need to
talk
more

Nobody
should live
in fear

BE
LOUD
please
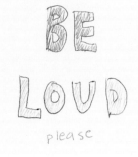

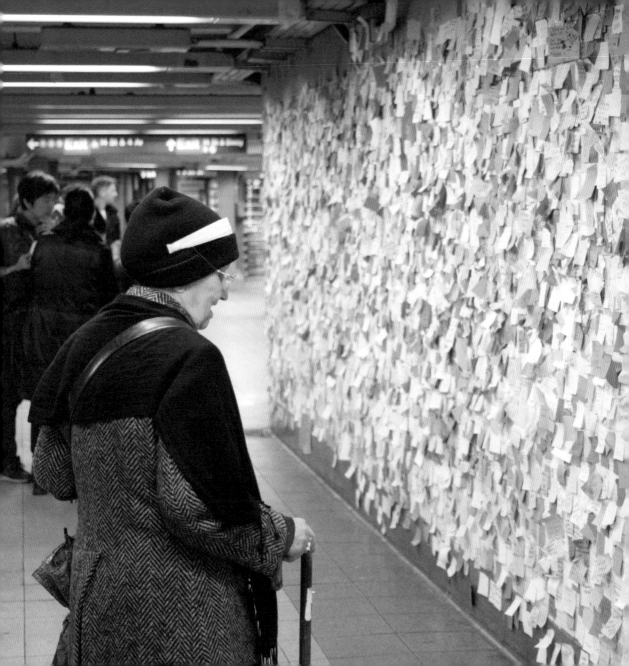

"When I give food to the poor, they call me a saint.

When I ask why the poor have no food, they call me a Communist."

— Paolo Freire

We can look different on the outside but we are all the same inside. Let's make a difference and respect & love each other ‿

Remember, I LOVE you.

Whoever you are, where-ever you are. Nothing will stop me from loving you.

We all have within us the seeds of love + the seeds of hate. Which do we choose to nurture?

We shall get through this!

We are a country built upon the ideals of freedom and inclusion. We are a country of immigrants, and we owe so much to those who sacrificed in the name of the American dream. We are stronger together!

People should not be thought of based on whether they are Mexican but rather based on who they are as a person

Undocumented people are not bad people! We live under the same sky, we breathe the same air, and we are just regular people Support DREAMERS!

I am Latina
My brother
is gay
My boyfriend
is Muslim
WE MATTER♡

Going to Canada
is not the
answer. Stand
together and
be strong ♡

be kind

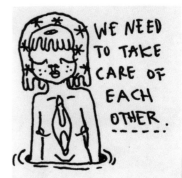

WE NEED
TO TAKE
CARE OF
EACH
OTHER.

This
is a
uterus ↳
It needs
protection.

We aren't
alone.
We have each
other to
lean on.

They thought they
could bury us.
They didn't know
we were seeds

—Mexican
Proverb

You
are
important.

DUDE ?!?!
Can we
please
do better?

Speak
your
Mind

I want peace
and I want
to help
others find
it, too.

As a girl, I didn't
need to be saved,
just HEARD.

Women's rights
=
Human rights

YOUR HIJAB is BEAUTIFUL

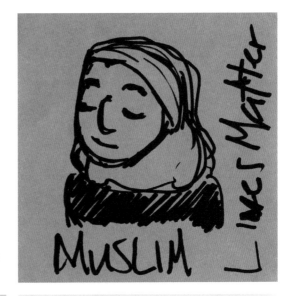

MUSLIM Lives Matter

Women's rights are human rights

"I don't have to be what you want me to be"
– Mohammed Ali :)

147

WE ARE
ALL
 HUMAN.
WE NEED TO
LOVE EACH
OTHER &
 PROTECT
 THE EARTH.

Protect
your Muslim
brothers &
 sisters

It's an honor
to be in this
struggle with you

ORGANIZE.
DONATE.
VOLUNTEER.
 &
SEND
LOVE.

Go into the
silence to
give voice
to the
 voiceless

ACT LOCALLY
DO GOOD
THINGS AND
STAY POSITIVE

fight for
the ones you
love.

I AM
- GENDERQUEER
- LESBIAN
- WOMAN
- BROWN
- MENTALLY ILL
AND I WILL NOT
GIVE IN TO HATE

Speak to your
fellow Americans,
especially the
ones you don't
understand.

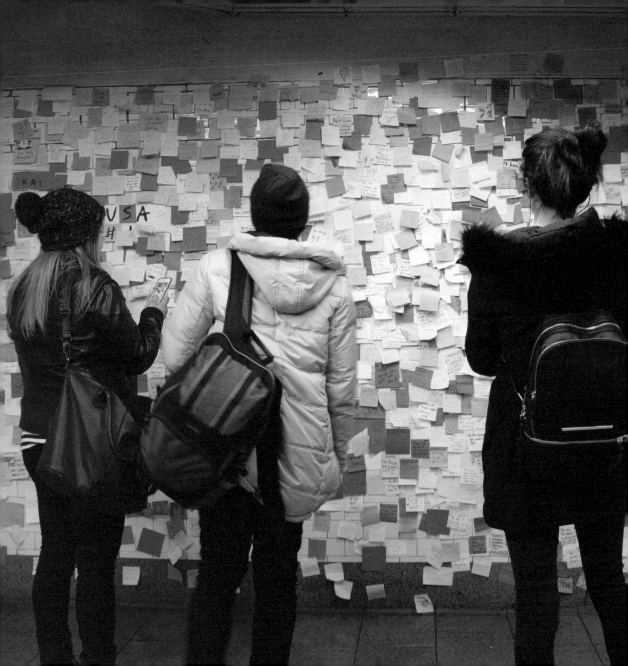

Keep up the small acts of kindness

YOU DESERVE THE SAME AMOUNT OF RESPECT AND DIGNITY AS EVERYBODY ELSE.

All we can do is hope and work for justice. If we don't work, who will? Always remember that you're not alone. ♡

Just keep making Music

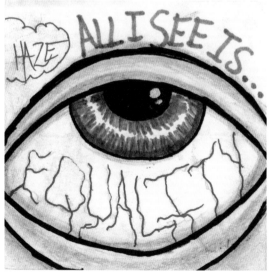

HAVE THE COURAGE
TO HAVE
HARD CONVERSATIONS

BE COMPASSIONATE
KEEP OPEN
KEEP STRONG
TO YOUR IDEALS.

I will not be a bystander.
I will stand up for you.
We all must stand up
for each other.

BE WHO YOU
ARE AND
DON'T
APOLOGIZE
FOR IT.

Take care
of
each other.

Your
existence
isn't a
crime

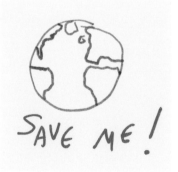

SAVE ME !

IDEAS
MATTER

YOU DON'T DECIDE
WHO YOU ARE

DECIDE WHO YOU
ARE GOING TO BE

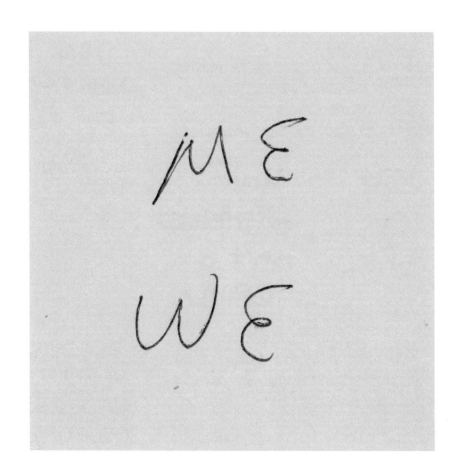

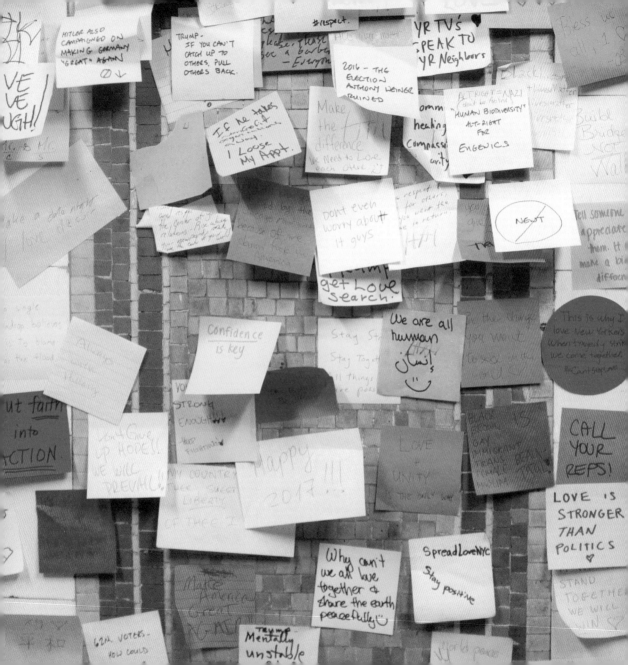

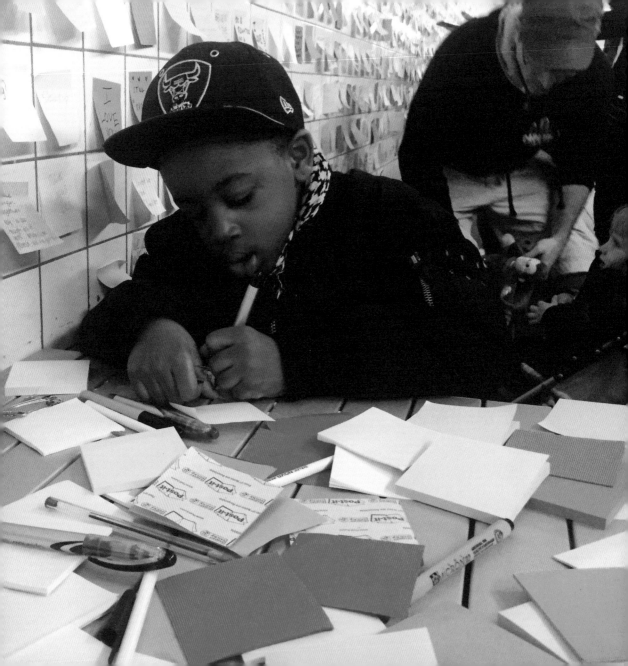

A CREATIVE TOOLKIT

DO YOU HAVE AN IDEA FOR A PROJECT
THAT YOU WANT TO BRING TO LIFE?

Below are seven creative steps that I found useful to the development of Subway Therapy. Looking back, I realize how much they have in common with the scientific method—investigating a phenomenon and designing ways to explore it. For me, inquiry began in the subway, that place where crowds spend so much time alone together. I started not so much with an overt question as with a sense of tension I wanted to resolve. I've often felt that creative movement begins with this kind of tension, which provokes curiosity, a desire for understanding.

STEP 1: OBSERVE

There is a difference between simply looking and really *seeing*. A quick look might only graze the surface, especially when it comes to human behavior. Take note of how people are presenting themselves, and then imagine how the world might look through *their* eyes. You might be surprised at what's revealed by taking a few extra moments to step back and consider.

At first glance, subway commuters struck me as indifferent to one another, but watching more closely, I began to notice slight glances, expressions, signs of suppressed energy that suggested, even if they weren't aware of it, that people were looking to be noticed or met, to find some form of connection in this anonymous space.

STEP 2: THINK (AND SHARE) LIKE CRAZY

When you're first forming a new idea, try to come at it from all angles and ask for feedback. Hearing other people's opinions and working out your thoughts through conversation will help you gather the information you need to shape your idea into something tangible.

It was through conversation with friends and acquaintances that my observations became ideas, and eventually, a good idea, one that could be put into action.

STEP 3: BUILD YOUR CONCEPT

Start with the skeleton of your best idea. Don't overthink it. It doesn't have to be perfect or work right away, because you can (and probably will) change it later.

Having decided on the action I wanted to take—providing people with a nonjudgmental ear—I asked myself: How could this appear in the real world? What kind of space would foster conversation and trust? What would that space look like? I settled on something simple: a table, two chairs, and a sign inviting people to stop and talk.

STEP 4: TRY IT

Go out and make your concept real. Both success and failure will help you fine-tune your concept. Embrace both, and your project will evolve and transform into something wonderful.

On my first day as New York Secret Keeper, I set up in four different subway stations. In one instance, I was asked to leave. By the end of the day I was able to identify which location was best for the project.

STEP 5: LISTEN AND BE OPEN TO CHANGE

As you test your concept, listen to the people around you, gather information and feedback, and always consider how your project might find its next identity. If you are open to the possibilities of change, you can let go of what you think the project *should* look like or be, and allow it to become what it was meant to be.

When I was acting as a Secret Keeper, many people remarked that interacting with me felt like therapy. I saw that the confidentiality I was offering made room for a broader role, and I began to move toward what became Subway Therapy. When people asked how they could stay updated on my project, I took steps to make it accessible online and through social media.

STEP 6: ADD ONTO OR TWEAK YOUR PROJECT

Most people don't buy the perfect house with everything they want in place exactly on day one. Try to let go of your expectations and start with a basic frame; fill out the structure until it's ready to be lived in, and then tend to the details that require attention. You can always rebuild, change things you grow tired of, or add little touches to perfect the experience.

While I enjoyed New York Secret Keeper, and kept the bare bones of that project in place, I also reworked the details as my purpose became clearer—things like adopting a name that arose organically, and then wearing a suit with a tie to perform that role. Over the next six months, Subway Therapy continued to change in small ways, which made the project more satisfying for me and for the people I was engaging with.

STEP 7: GO BACK TO STEP 1

Going back to Step 1 doesn't necessarily mean scrapping the idea and starting from scratch, though that's always a possibility! Going back just means being willing to apply what you've learned, whether you're modifying your first iteration or breathing life into a fresh idea. Whichever way you go, know you can always start over, and remember that starting over doesn't mean you've failed—it means you're giving yourself the gift of a fresh start.

ACKNOWLEDGMENTS

I started Subway Therapy because I felt immeasurably lucky to have friends and family who supported me. It would be impossible to express in words how grateful I am for them, and I feel so overwhelmed by their support and love that I have made it my mission in life to support others in the same way.

First, I must thank my entire family for giving me the love I needed to thrive and pursue my passions. Thank you, Mom and Dad, for providing me with the opportunity and means to shape myself into the person I am today.

Since I moved to New York I have owed a debt of gratitude to my friend and aunt, Laura Holson. Without your sound advice and support this project wouldn't have grown like it did. You inspire me to be my best, and I am filled with wonderful ideas after our conversations.

There probably isn't much I haven't already said to my friends, but I must say thank you again to the people that made the weight of Subway Therapy easier to carry. Thank you, Dominic Pody, Aaron Cohen, Lily Arbisser, Cathianna Bartolomeo, Charlene Wang, Gabrielle Williams, Nate Blevins, Shannon Hayes, Trish Lipscomb, and Dalton Weeks.

At Foundry Literary and Media, I'm eternally grateful to Yfat Reiss Gendell for being the best agent imaginable, and to Jessica Felleman, who is one of the most hardworking people I have ever met. And to the individuals who work behind the scenes, thank you, Sara DeNobrega, Colette Grecco, Kirsten Neuhaus, and Heidi Gall. The obstacles that you helped me overcome were impossible for me to see before they came, and I am relieved to have such a talented and inventive team by my side.

To the staff at the Topaz, I can't tell you how important it was that you supported me when I needed to be in the subway instead of behind the bar. Thank you, Brandon Davey, Logan Price, James Angelos, Jeremiah Neal, Diego Garcia, Bruno Daniel, Rutger Mckenna, and Anwar Nunez.

From the beginning, Bloomsbury Publishing has been incredible to work with. Nancy Miller, thank you for helping me shape my ideas into reality. Your passion and dedication to the book and my work inspire me to do more. I presented the art department with an interesting challenge. As a medium, sticky notes aren't the easiest to work with, but Patti Ratchford and Katya Mezhibovskaya were able to bring them to life in print. It has also been a pleasure to work with Callie Garnett, Laura Phillips, Marie Coolman, Sarah New, Rayshma Arjune, Cristina Gilbert, Laura Keefe, Nicole Jarvis, Cindy Loh, Grace McNamee, Jennifer Kelaher, and at Macmillan, Eve Fitzgerald.

The people who work at the MTA in New York rarely get the credit they deserve, but I respect them so much, and they supported free expression and fostered a connection with the community in a time when they needed it most.

Adam Shorr, you are my best friend, and when I needed help the most with Subway Therapy you were there. You brought sticky notes on day one when I ran out, answered e-mails, edited my words, carried heavy tables, listened to hours of terrible buskers, and in general kept me going when I would have otherwise burnt out. You have always been someone who has kept me on the right track, and because of your guidance and friendship, I feel like I am exactly where I am supposed to be.

And last but certainly not least, thank you to the strangers and volunteers who contributed in some way by donating sticky notes, spending time, bringing me food, or walking with me when I had too much to carry by myself. I may not remember all of your names, but I'll never forget that when I needed something you were there for me, and you had no reason to do that.

Thank you for helping me to help others.